MAY 30 2009

D0598201

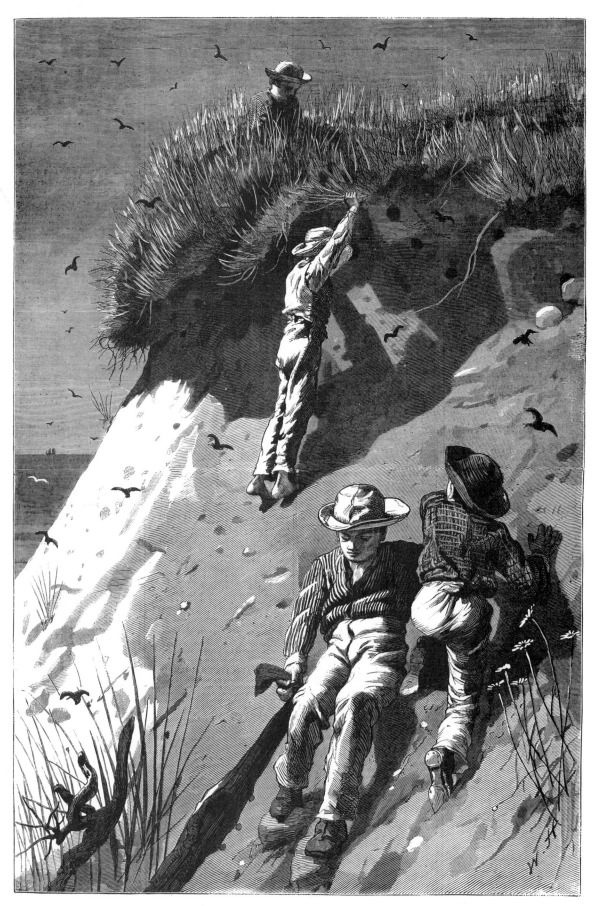

Raid on a Sand-Swallow Colony—"How Many Eggs?" *Harper's Weekly*, June 13, 1874.
13⅜ x 9⅛ inches.

WINSLOW HOMER
ILLUSTRATIONS

41 WOOD ENGRAVINGS
AFTER DRAWINGS BY THE ARTIST

Dover Publications, Inc., New York

PUBLISHER'S NOTE

Prominent among America's most admired artists is Winslow Homer (1836–1910). His reputation is based primarily on his seascapes in oil and in watercolor, which date from the second part of his career, marked by his move to Prout's Neck, Maine, in 1883. It is less generally known that, until that time, Homer earned his living as an illustrator for many of the great periodicals of the day, including *Ballou's Pictorial, Harper's Weekly, Frank Leslie's Illustrated Newspaper* and *Harper's Bazar*. He had been prepared for work in the field by a two-year apprenticeship in the lithography shop of J. H. Bufford which began when he was eighteen. During that period he met Charles F. Damoreau, from whom he learned the technique of designing for wood engravings. In 1857 Homer began his career as a free lance in Boston, moving to New York City two years later. *Harper's Weekly* sent him to Washington to cover Lincoln's first inauguration; he later depicted Civil War camp and battle scenes for the same publication. Homer's work, also consisting of scenes of urban and rustic activities, beach scenes, scenes with children and illustrations for stories, made him one of the most popular artists in the field. However, in the mid-1870s his production in this medium ceased.

Since Homer's output of engravings was considerable and the ability of his engravers (over twenty in the course of his career) was uneven, the illustrations are of widely varying quality. This collection consists of those that are strongest, representing the best of the artist's endeavors (and his engravers' skills). They reveal Homer's gift for composition and his experimentation with linear and tonal values. Much has been made of the influence of Japanese prints on his art, as well as the possible influence exerted by Millet, Courbet and some of the Impressionists (Homer spent ten months in France in 1866–67), yet all of his works bear his own unique stamp.

ACKNOWLEDGMENTS

The publisher gratefully acknowledges the help of Mr. Scott Elliott of the Kelmscott Gallery, 410 South Michigan Avenue, Chicago, Ill. 60605 for his advice in making this selection and for providing for reproduction the plates on pages 3, 8, 11, 13, 14, 18, 20/21, 27, 29, 31, 33, 36/37, 38, 39, 40, 41, 42.

Thanks are also extended to Mr. Bernhardt Crystal, The Washington Irving Gallery, 117 East 17th Street, New York, N.Y., for making available for reproduction the plates on pages ii, 15, 16, 17, 19, 22, 23, 30 and 31.

Library of Congress Cataloging in Publication Data

Homer, Winslow, 1836–1910.
Winslow Homer illustrations.

(Dover art library)
1. Homer, Winslow, 1836–1910. 2. United States in art. I. Title. II. Series.
NE1112.H6A4 1982 769.92'4 82-9459
ISBN 0-486-24392-3 AACR2

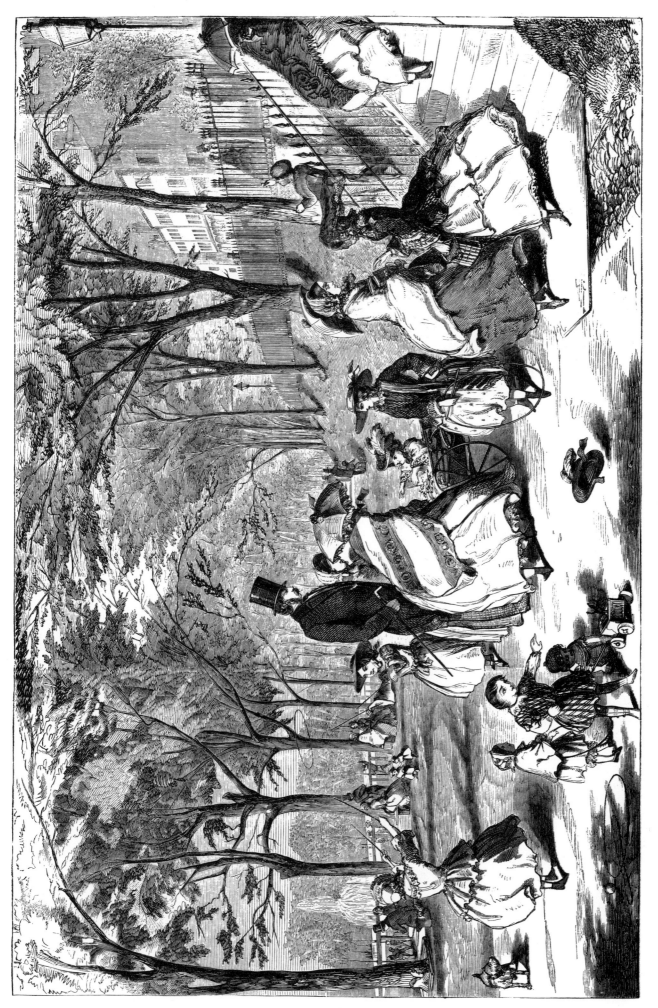

The Boston Common. *Harper's Weekly*, May 22, 1858. 9¼ x 14 inches.

1

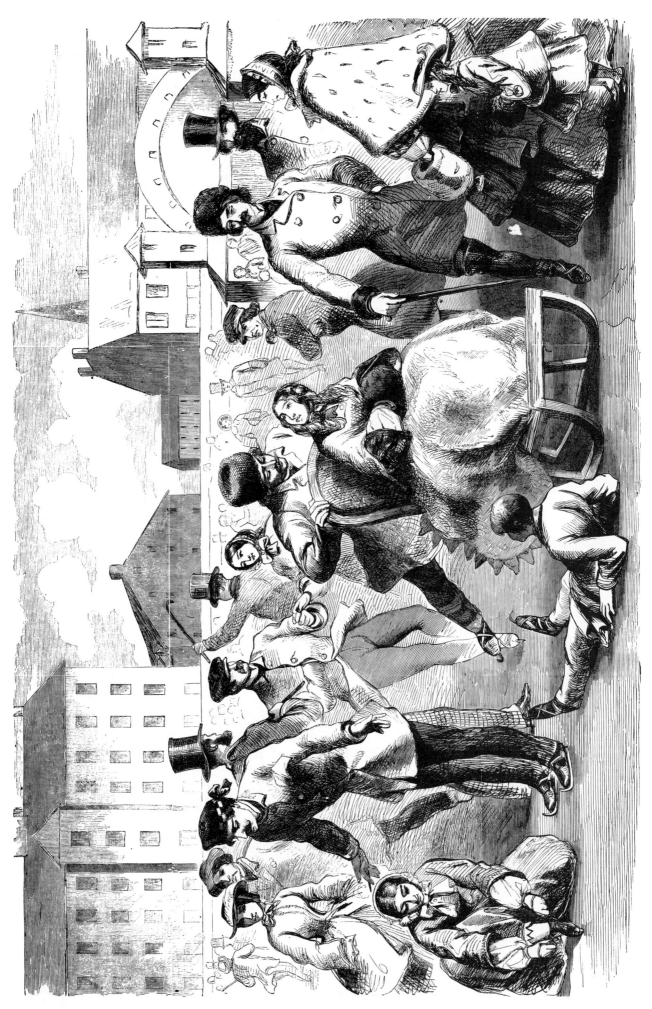

Skating at Boston. *Harper's Weekly*, March 12, 1859. 9¼ x 13¾ inches.

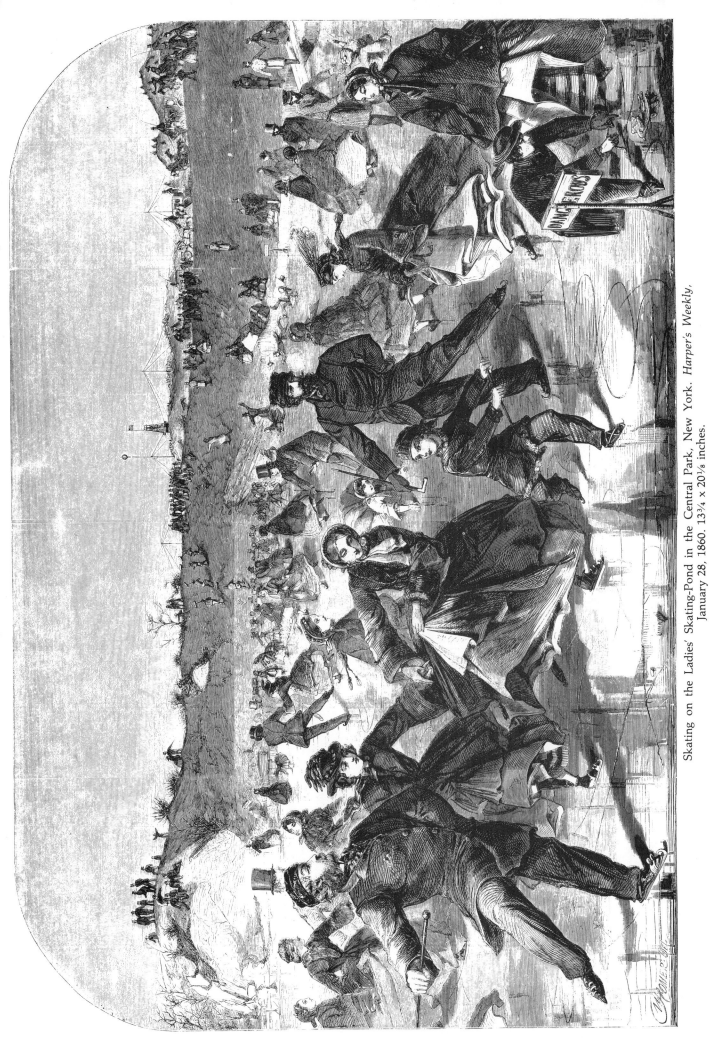

Skating on the Ladies' Skating-Pond in the Central Park, New York. *Harper's Weekly,*
January 28, 1860. 13¾ x 20⅛ inches.

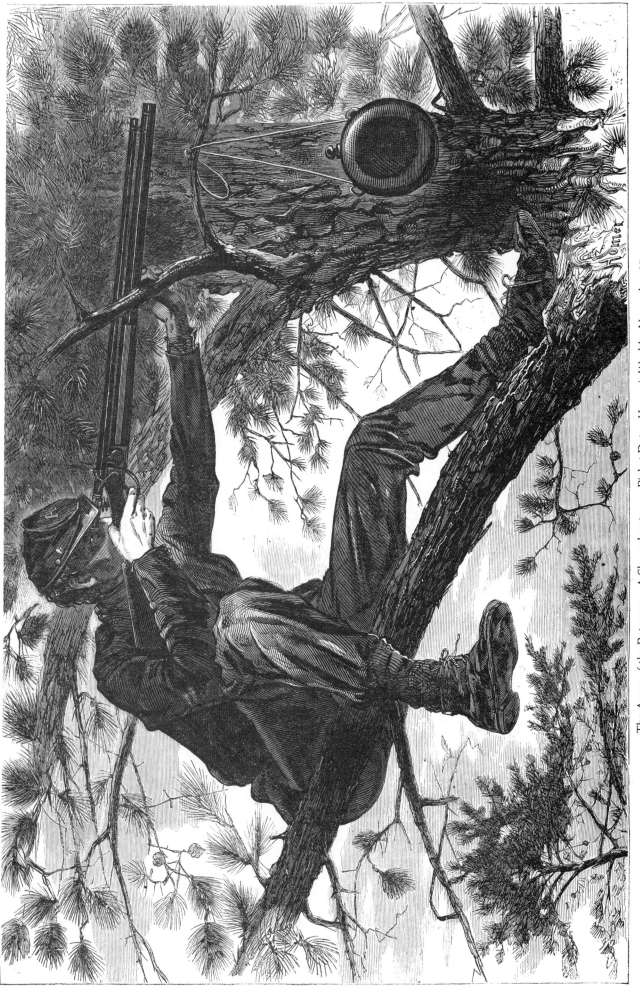

The Army of the Potomac — A Sharpshooter on Picket Duty. *Harper's Weekly*, November 15, 1862. 9⅛ x 13¾ inches.

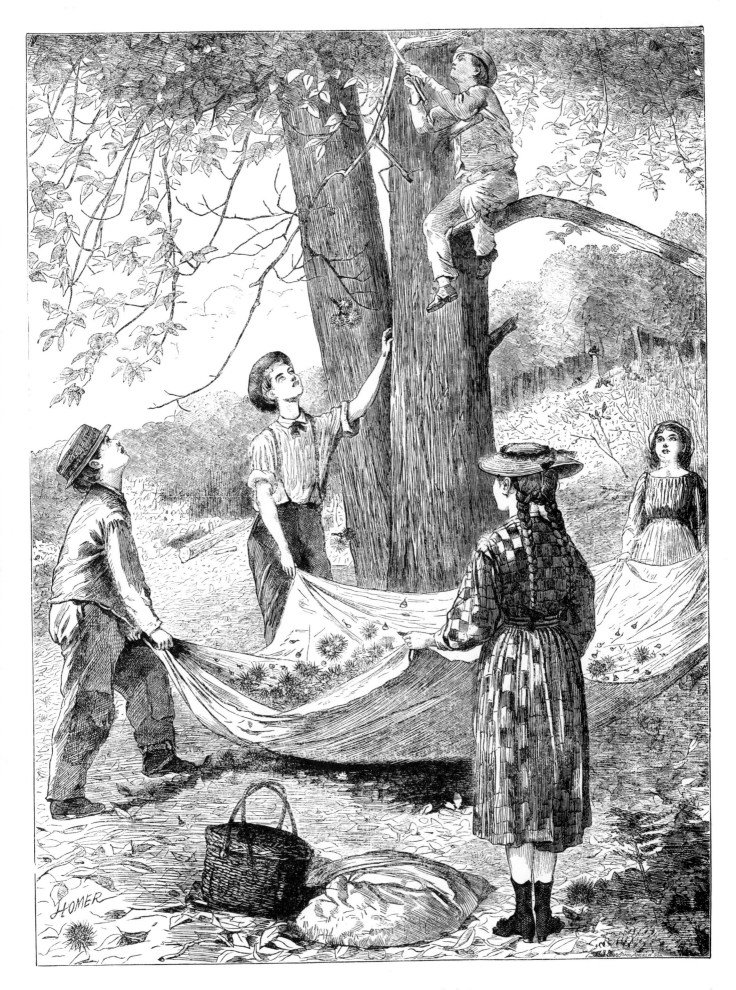

Chestnutting. *Every Saturday*, October 29, 1870. 11¾ x 8¾ inches.

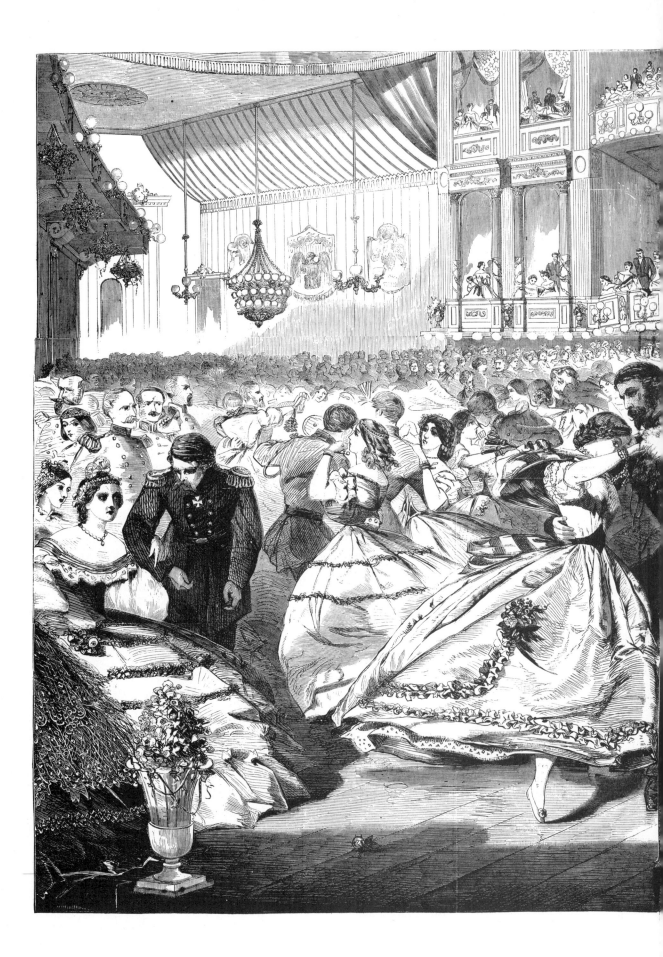

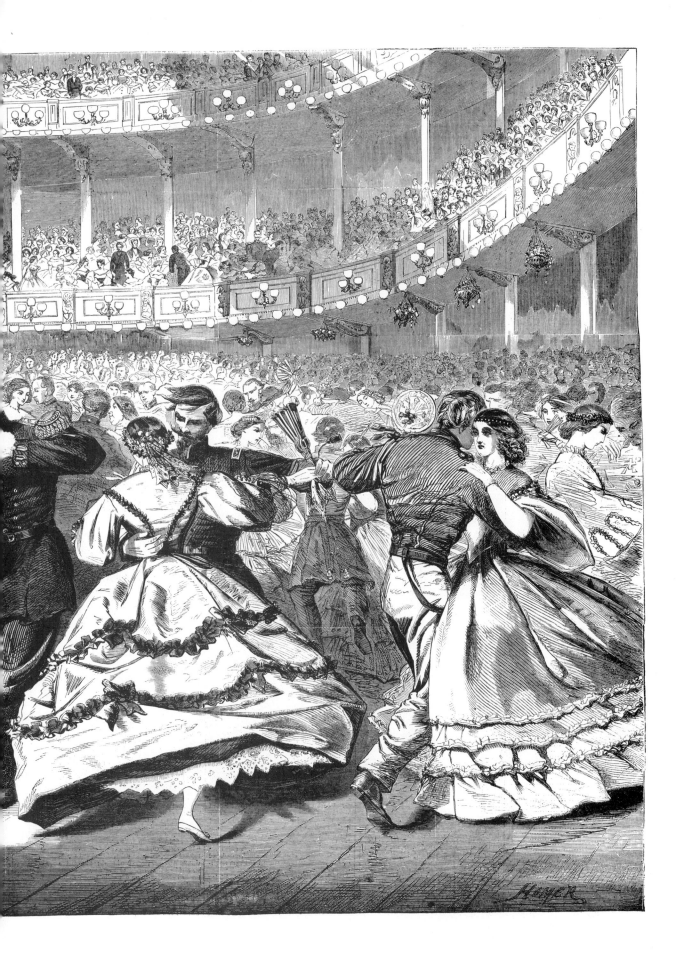

The Great Russian Ball at the Academy of Music, November 5, 1863. *Harper's Weekly,*
November 21, 1863. 13⅛ x 20⅜ inches.

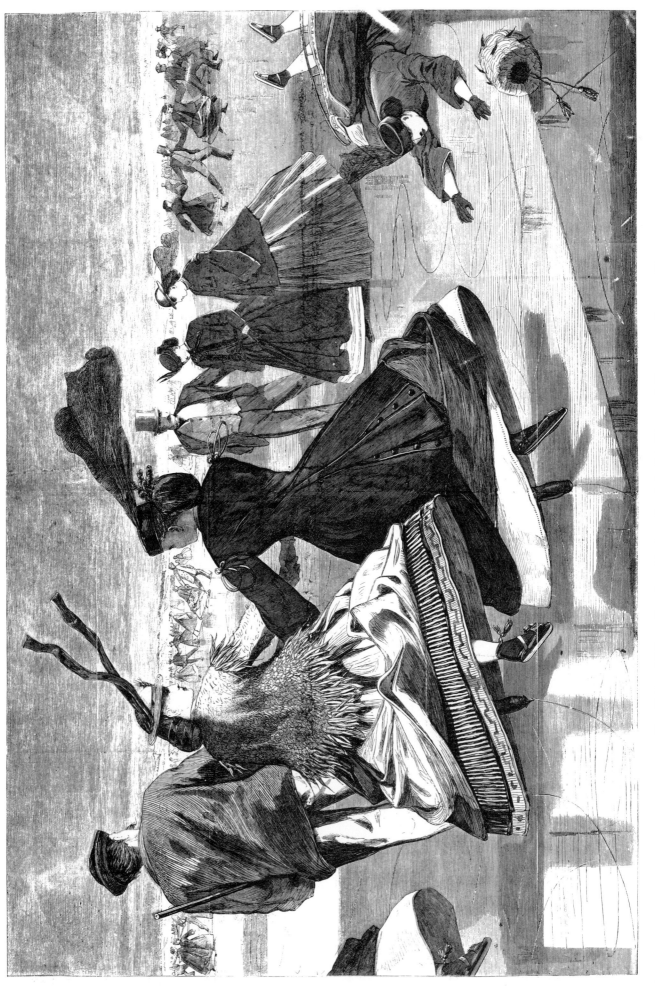

Our National Winter Exercise – Skating. *Frank Leslie's Illustrated Newspaper*, January 13, 1866. 14 x 20½ inches.

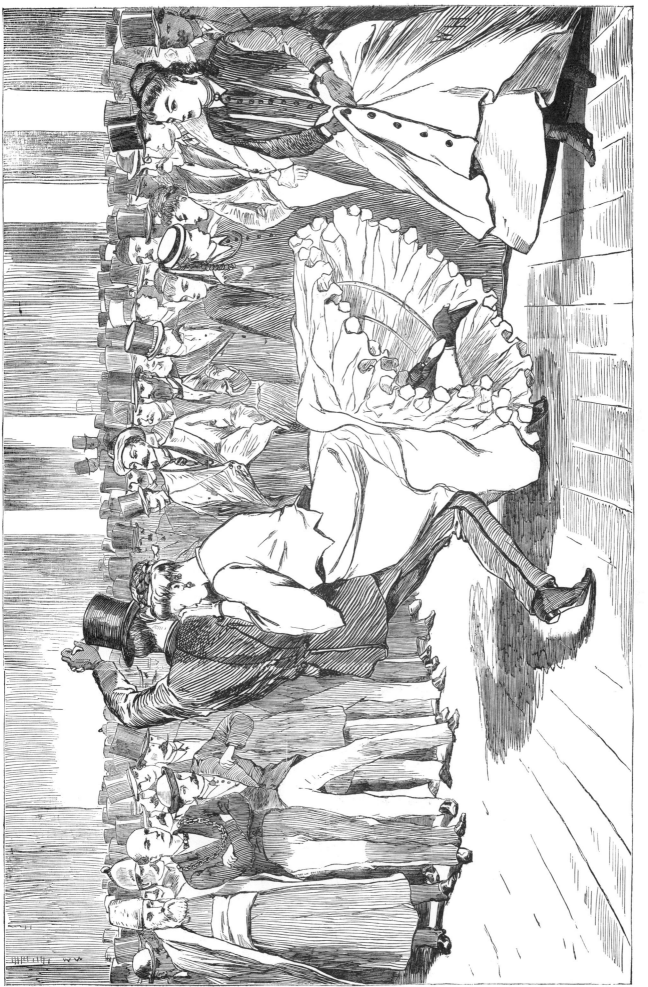

A Parisian Ball – Dancing at the Casino. *Harper's Weekly*, November 23, 1867. 9⅛ x 13¾ inches.

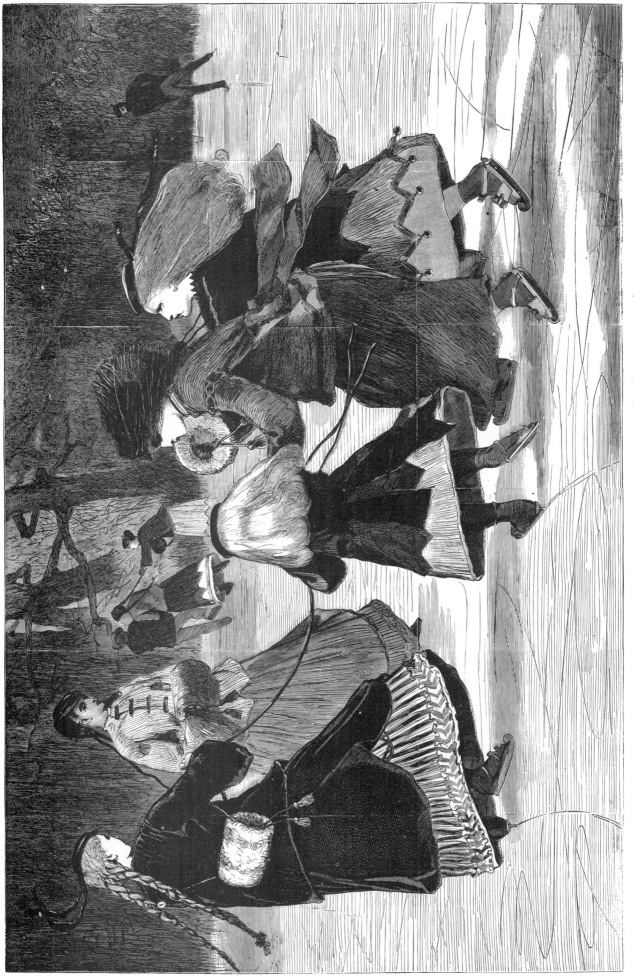

"Winter" — A Skating Scene. Harper's Weekly, January 25, 1868. 9 x 13½ inches.

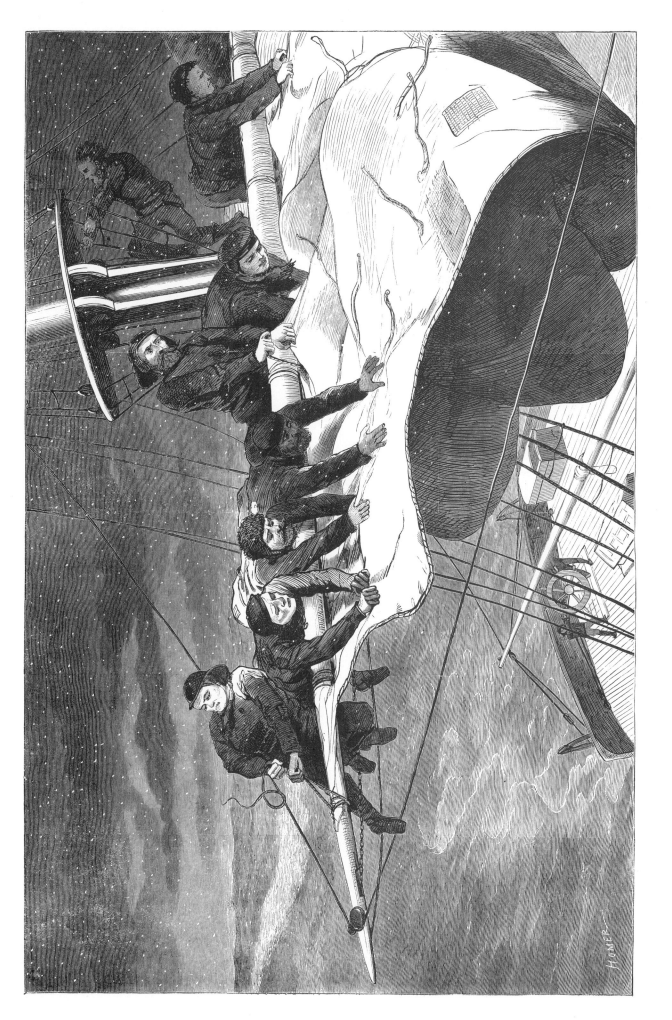

Winter at Sea – Taking In Sail Off the Coast. *Harper's Weekly*, January 16, 1869.
8⅞ x 12⅞ inches.

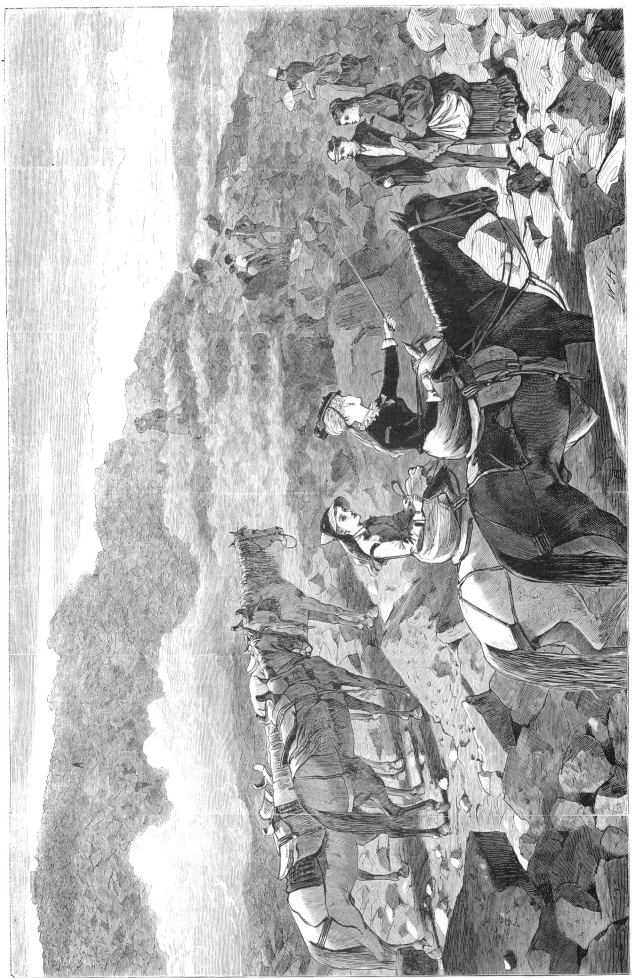

The Summit of Mount Washington. *Harper's Weekly,* July 10, 1869. 13¾ x 9 inches.

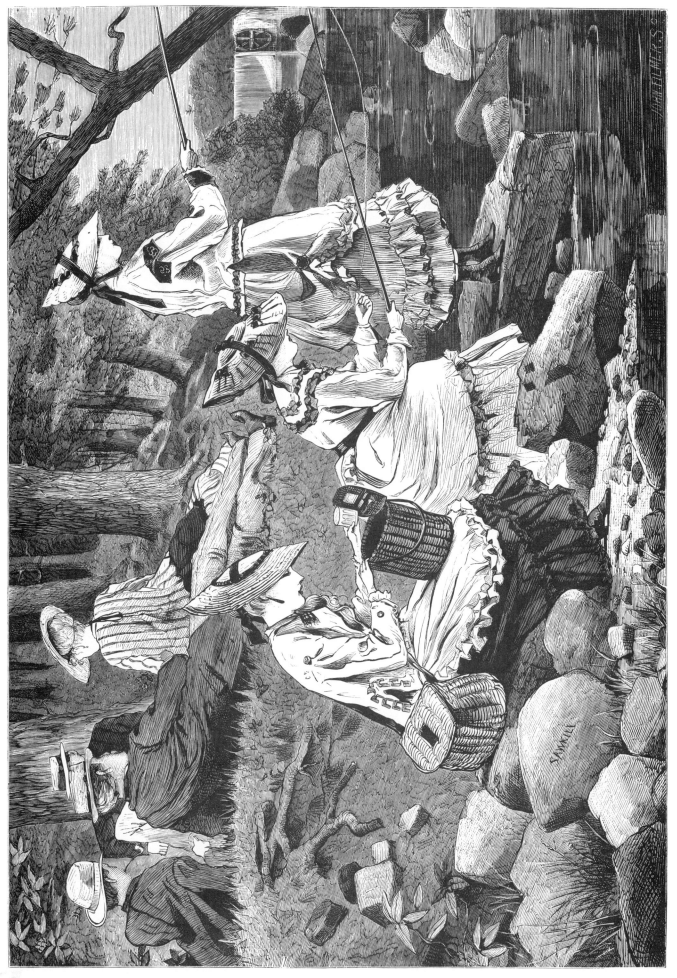

The Fishing Party. *Appleton's Journal*, October 2, 1869. 9 x 13¾ inches.

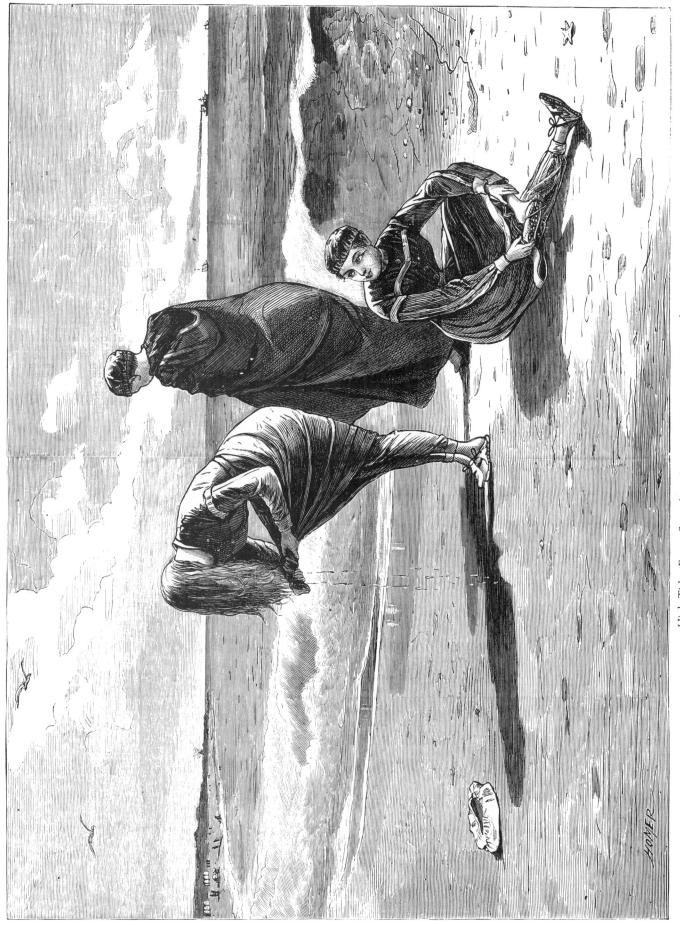

High Tide. *Every Saturday,* August 6, 1870. 8⅞ x 11¾ inches.

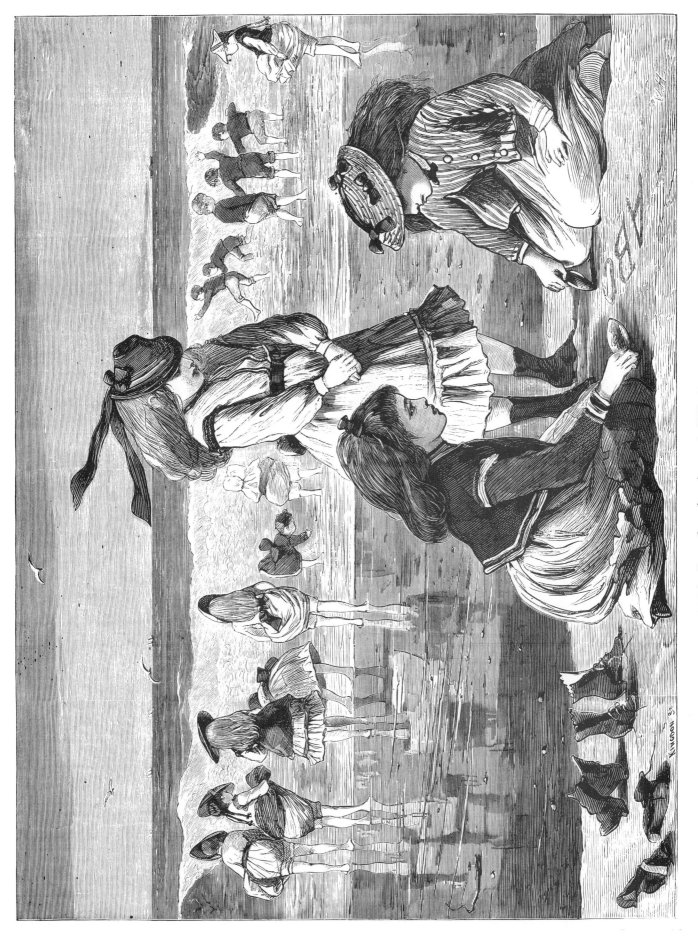

Low Tide. Every Saturday, August 6, 1870. 8⅞ x 11¾ inches.

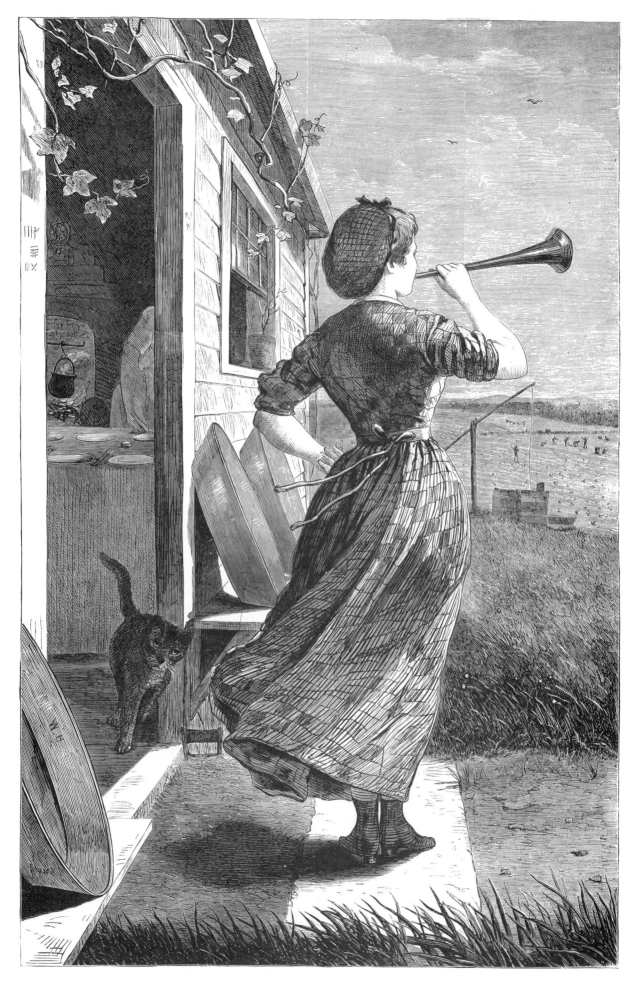

The Dinner Horn. *Harper's Weekly*, June 11, 1870. 13¾ x 9 inches.

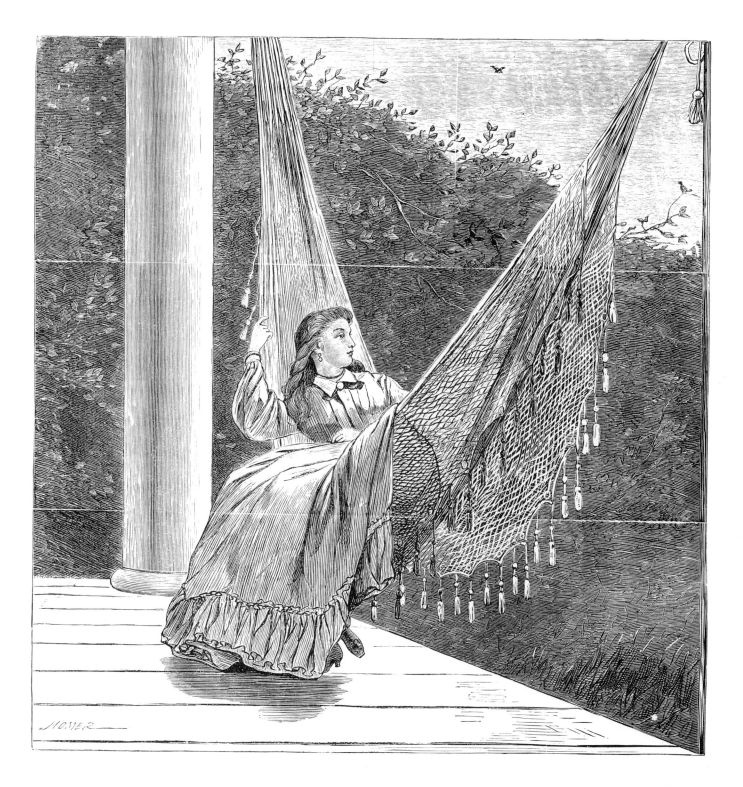

The Robin's Note. *Every Saturday,* August 20, 1870. 9 x 8⅞ inches.

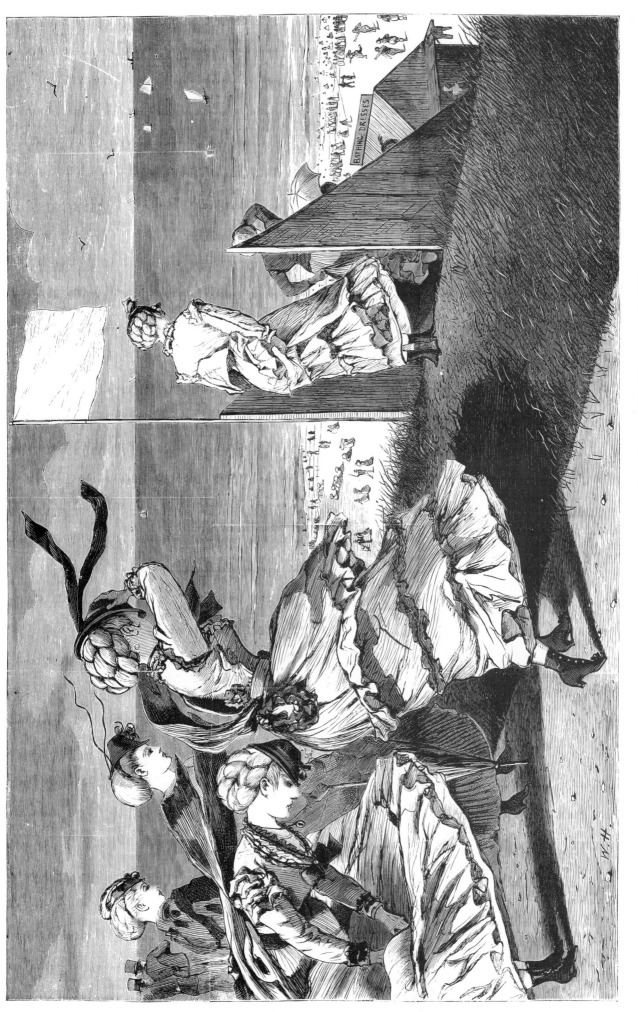

On the Bluff at Long Branch, at the Bathing Hour. *Harper's Weekly*, August 6, 1870.
8⅞ x 13⅝ inches.

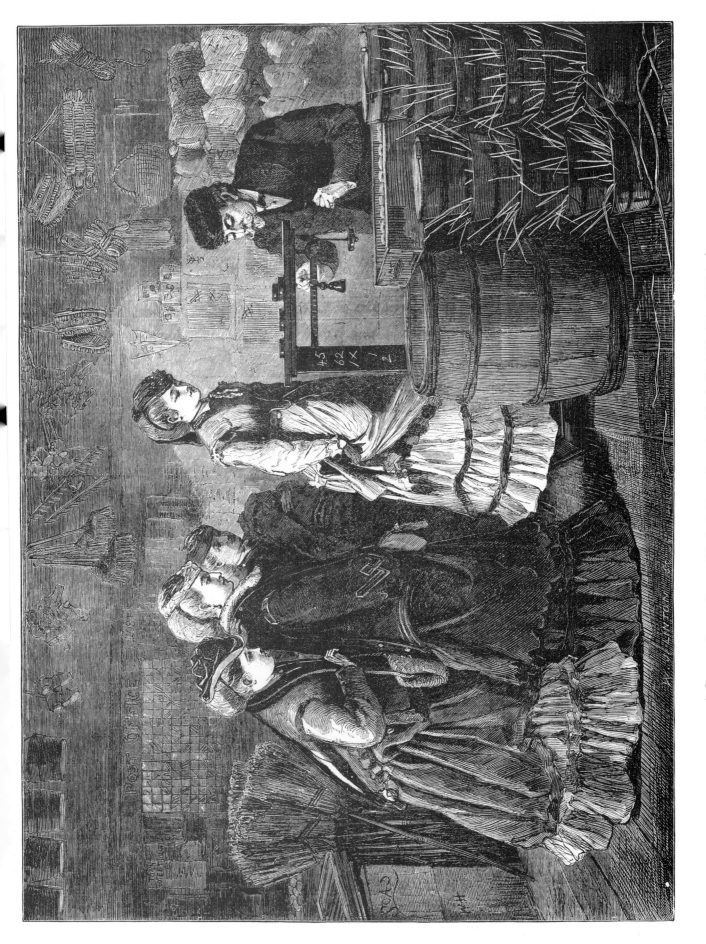

A Country Store — Getting Weighed. *Every Saturday*, March 25, 1871. 8⅞ x 11⅝ inches.

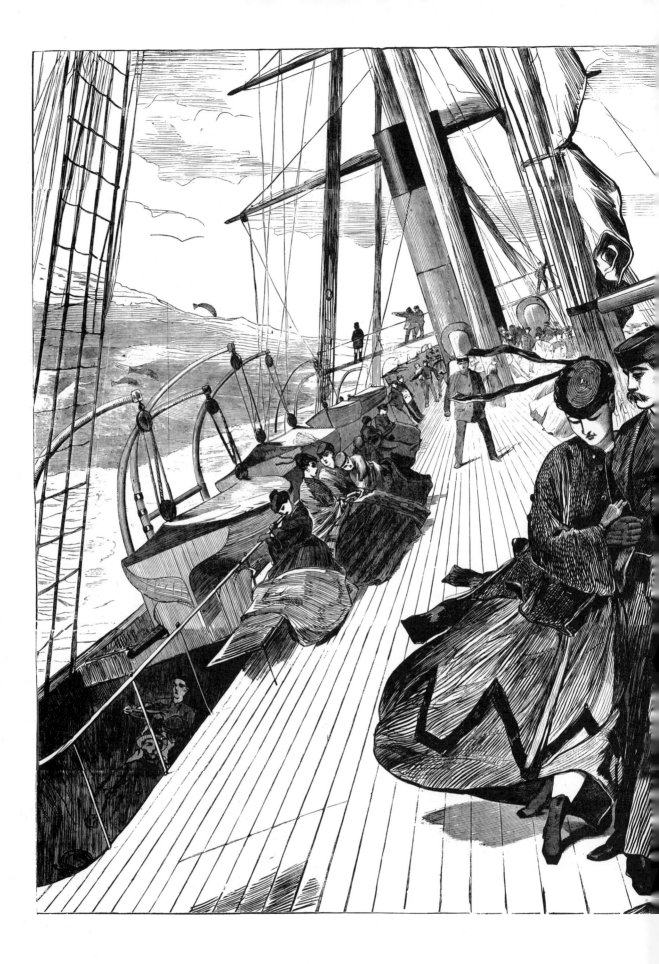

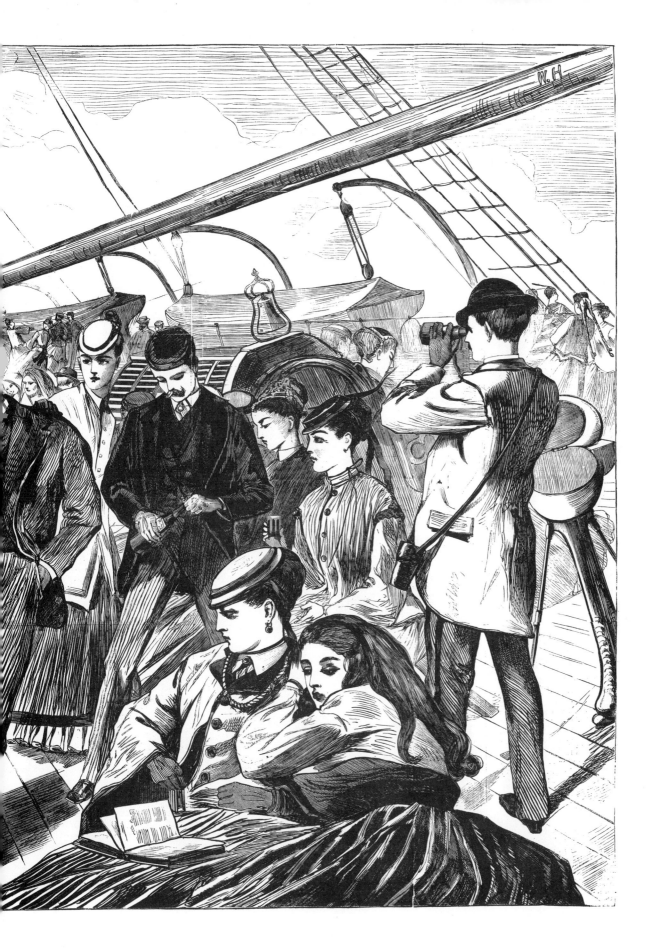

Homeward Bound. *Harper's Weekly*, December 21, 1867. 13⅞ x 20⅜ inches.

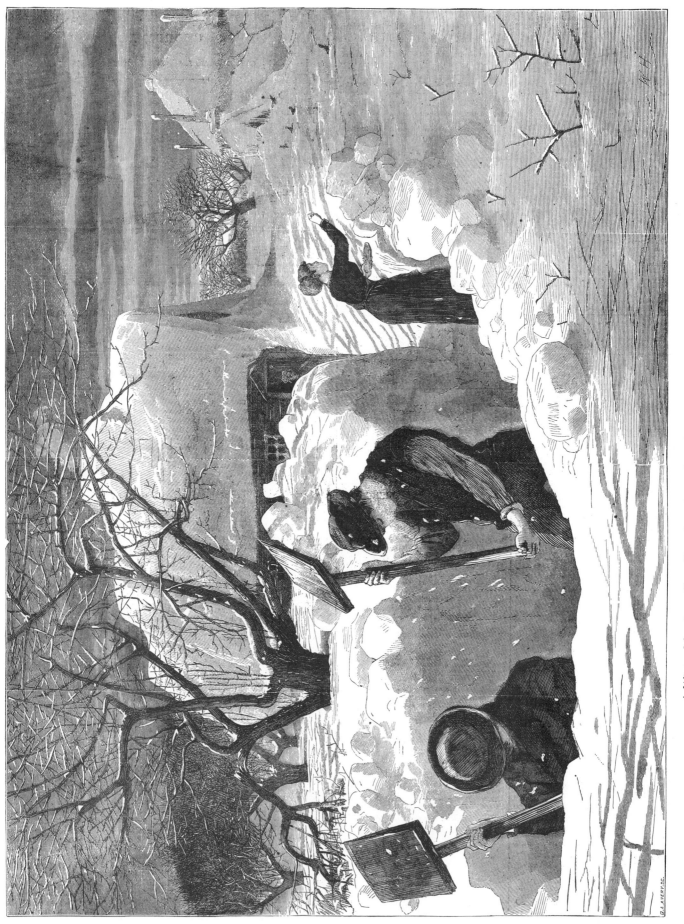

A Winter Morning – Shovelling Out. *Every Saturday*, January 14, 1871. 8⅞ x 11¾ inches.

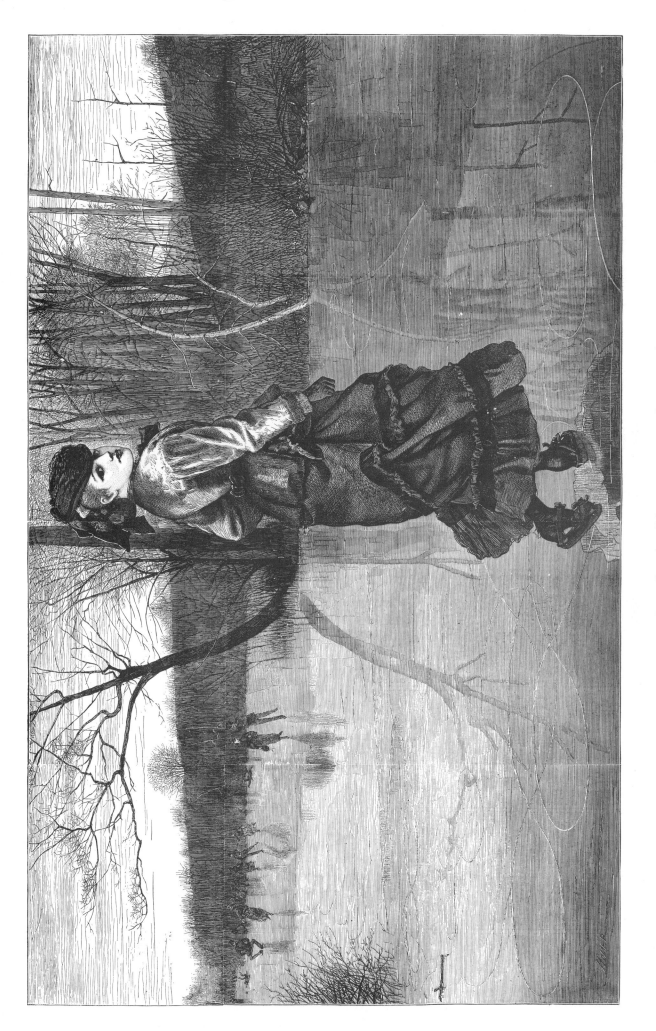

Cutting a Figure. *Every Saturday*, February 4, 1871. 11¹¹/₁₆ x 18⁵/₈ inches.

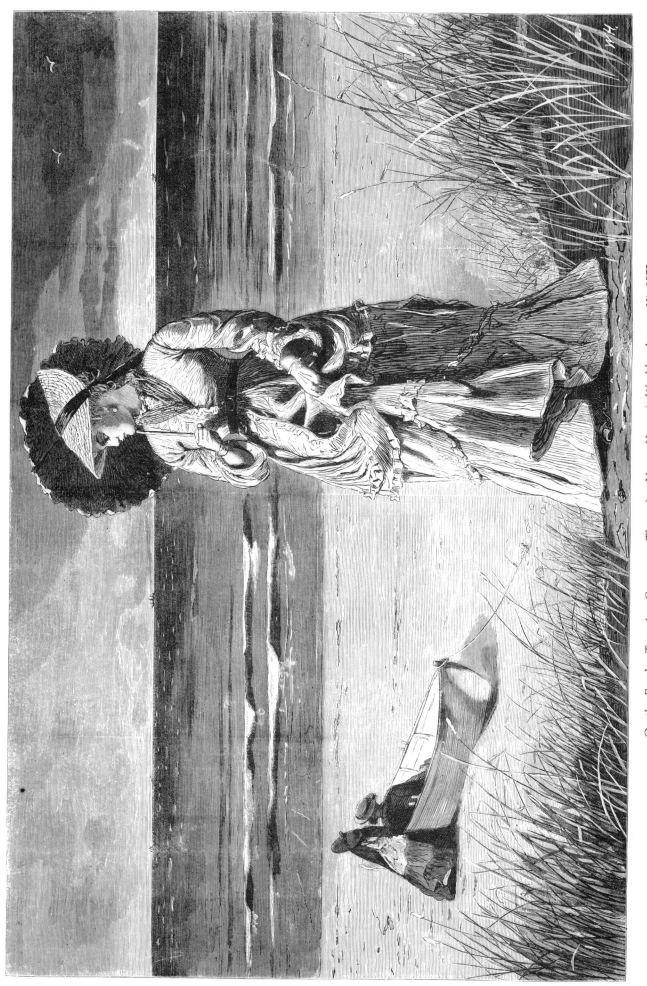

On the Beach—Two Are Company, Three Are None. *Harper's Weekly,* August 17, 1872.
9⅛ x 13¾ inches.

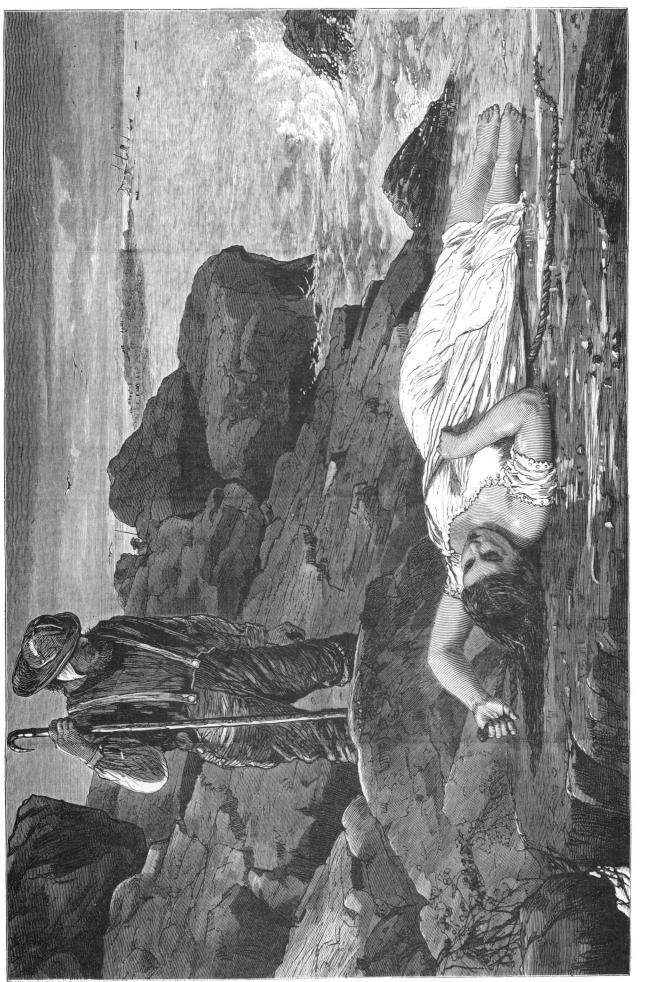

The Wreck of the "Atlantic" — Cast Up by the Sea. *Harper's Weekly*, April 26, 1873.
9⅛ x 13¾ inches.

25

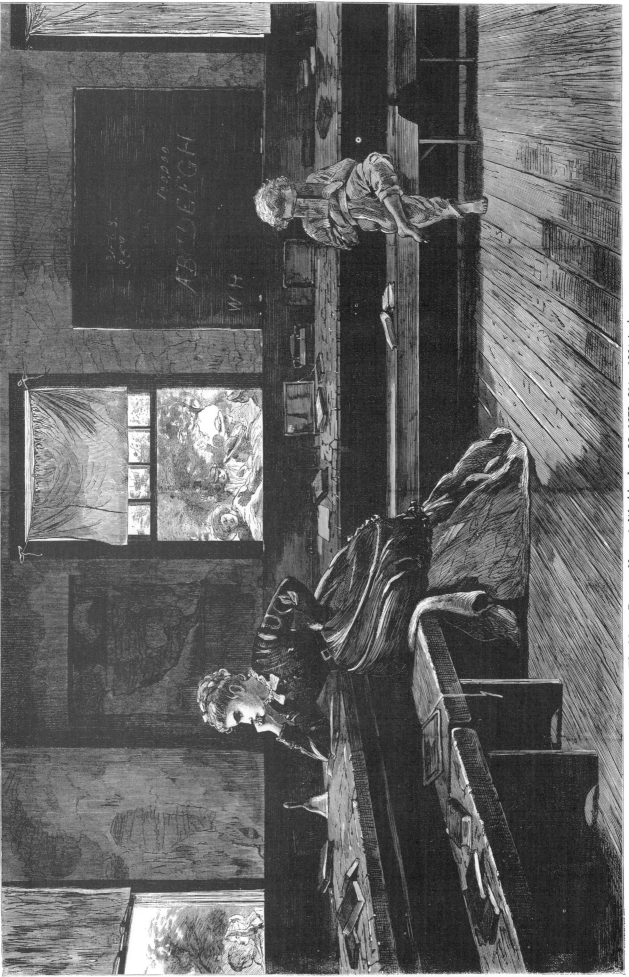

The Noon Recess. *Harper's Weekly,* June 28, 1873. 9⅛ x 13⅝ inches.

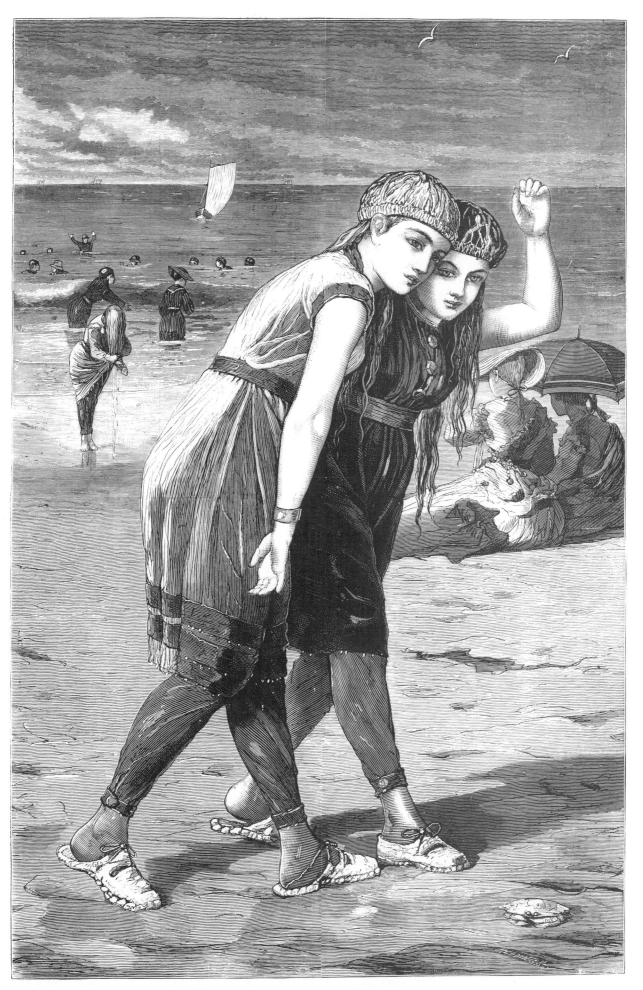

The Bathers. *Harper's Weekly*, August 2, 1873. 13¾ x 9¼ inches.

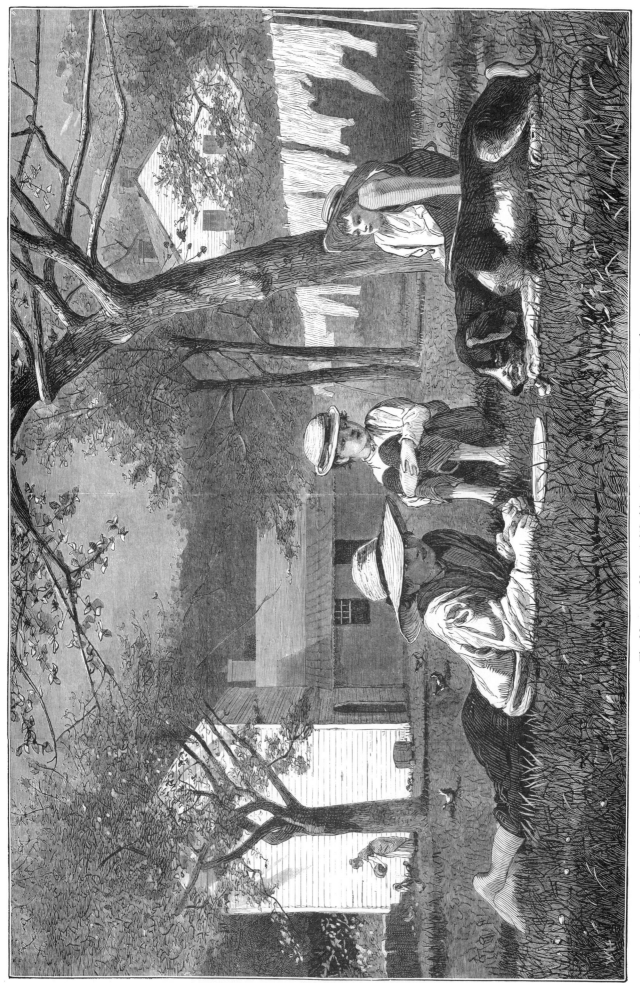

The Nooning. *Harper's Weekly,* August 16, 1873. 9 x 13¾ inches.

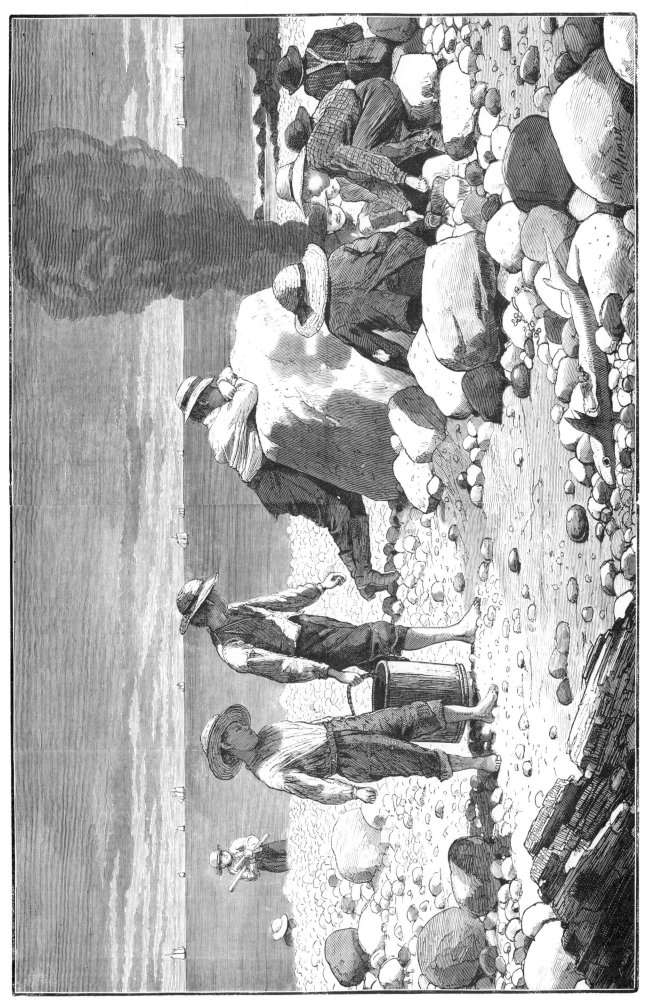

Sea-Side Sketches – A Clam-Bake. *Harper's Weekly*, August 23, 1873. 9¼ x 14 inches.

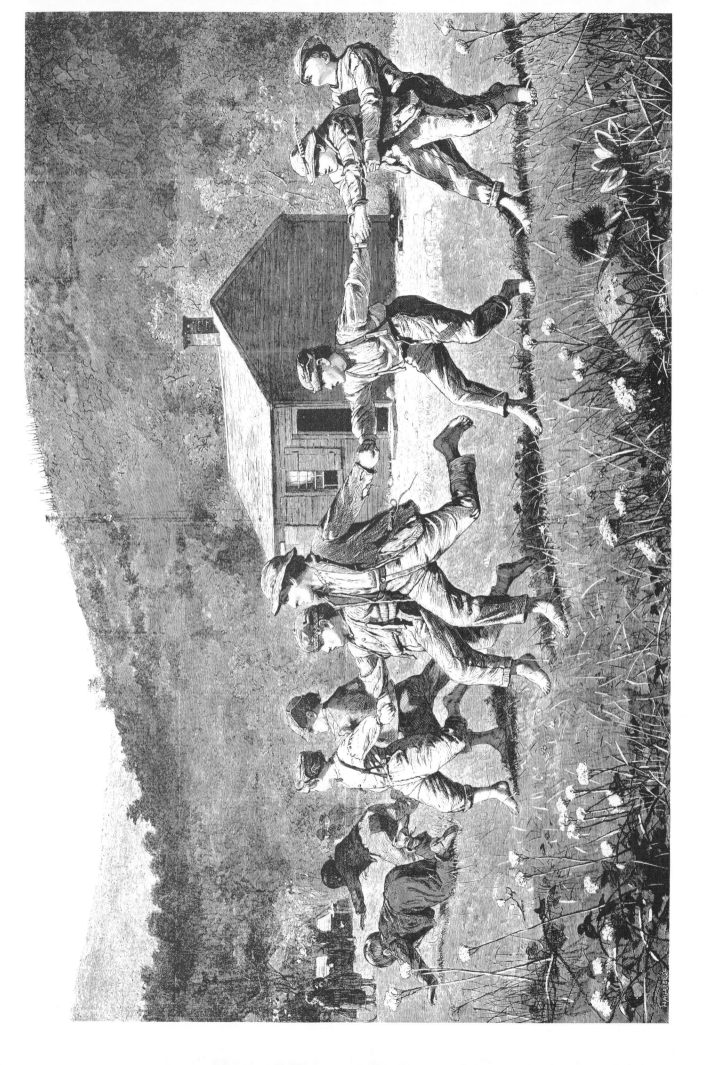

"Snap-the-Whip." *Harper's Weekly*, September 20, 1873. 13⁹/₁₆ x 20⁵/₈ inches.

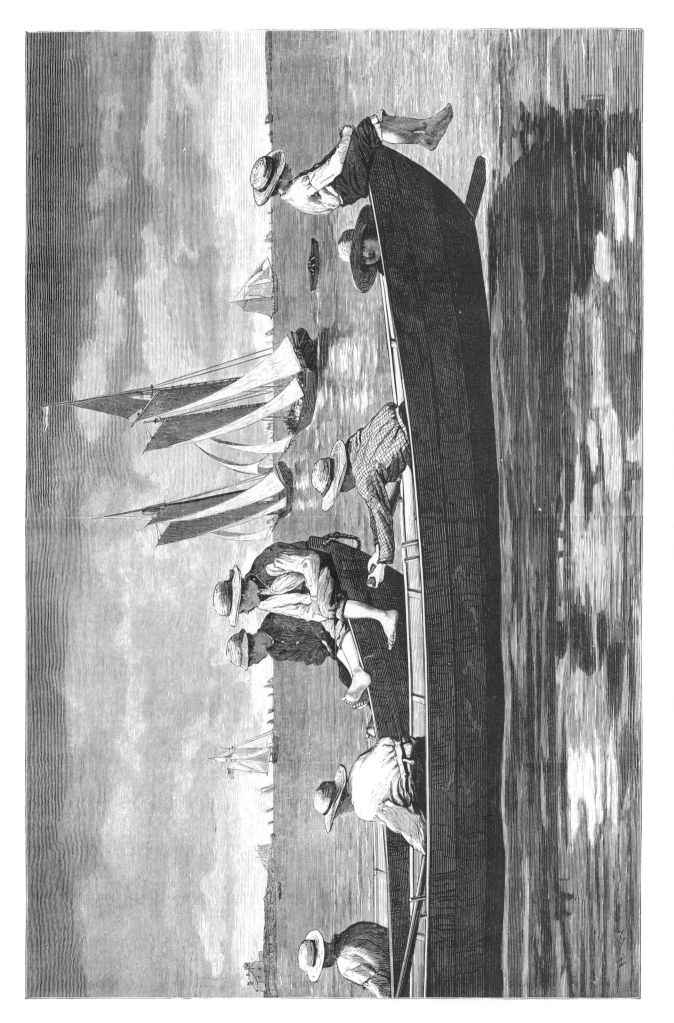

Gloucester Harbor. *Harper's Weekly*, September 27, 1873. 9⅜ x 14 inches.

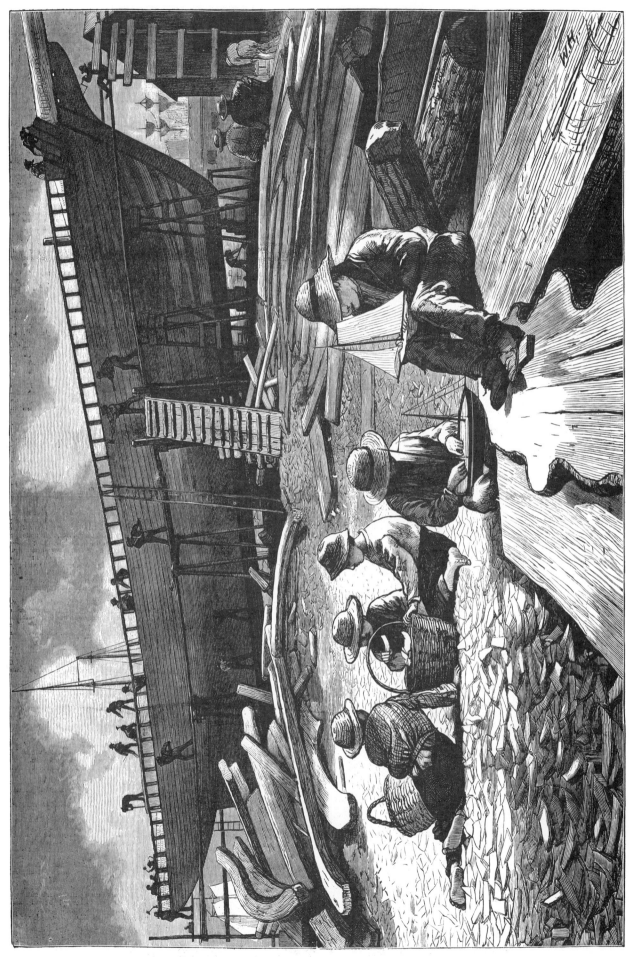

Ship-Building, Gloucester Harbor. *Harper's Weekly,* October 11, 1873. 9⅜ x 13¾ inches.

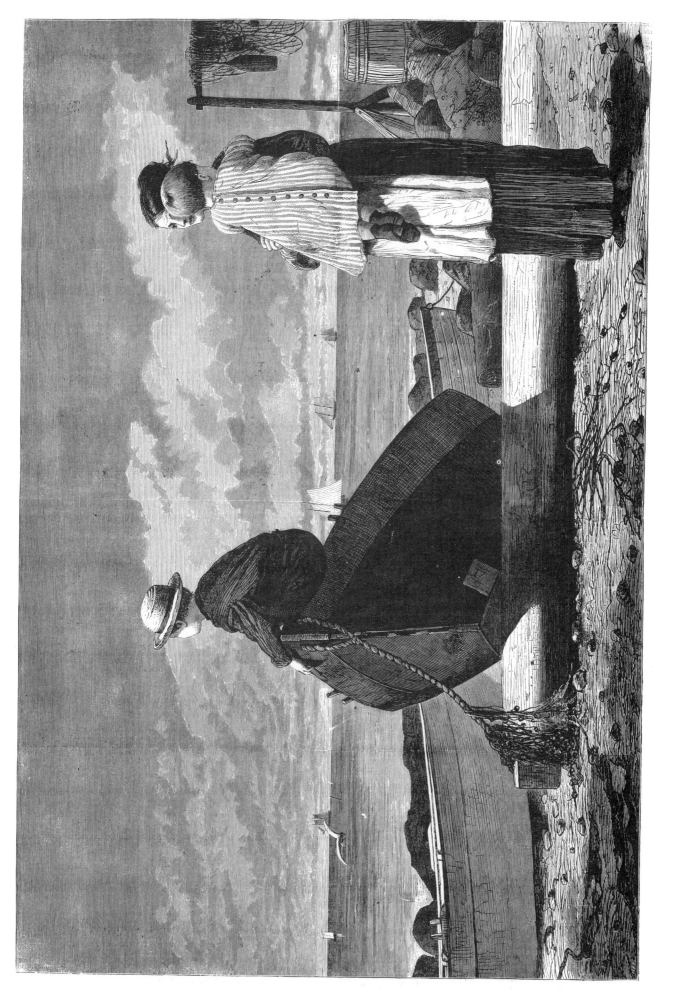

"Dad's Coming!" *Harper's Weekly,* November 1, 1873. 9¼ x 13½ inches.

33

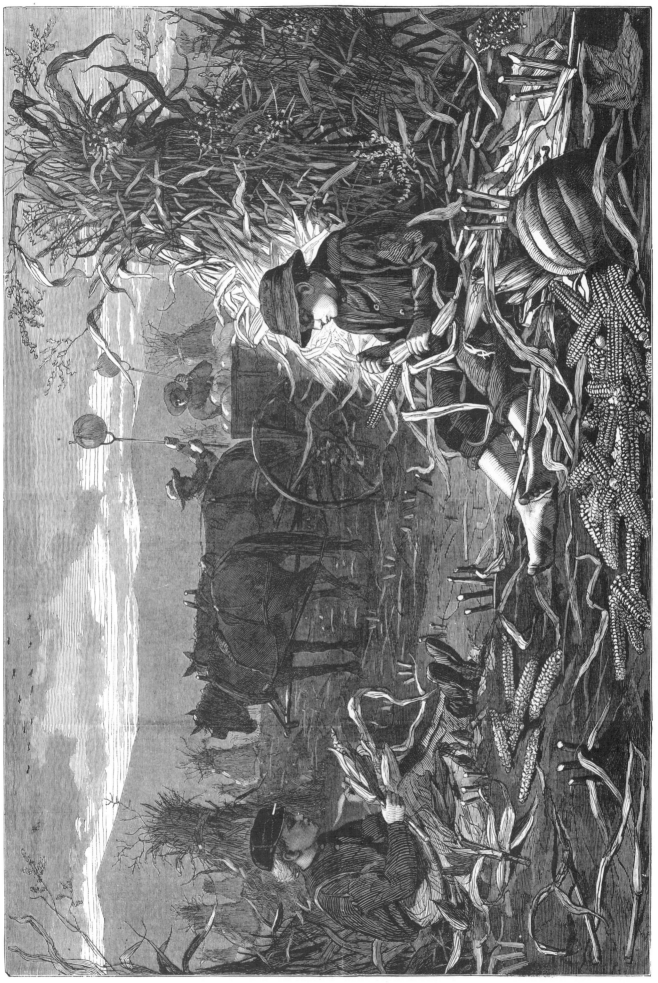

The Last Days of Harvest. *Harper's Weekly*, December 6, 1873. 9¼ x 13⅜ inches.

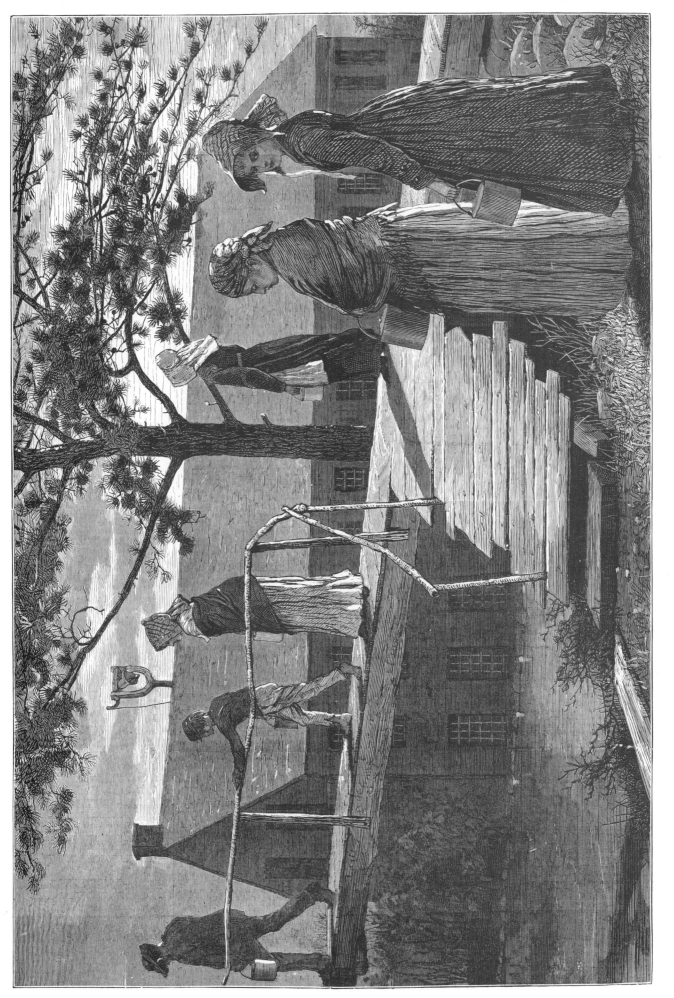

The Morning Bell. *Harper's Weekly*, December 13, 1873. 9⅛ x 13½ inches.

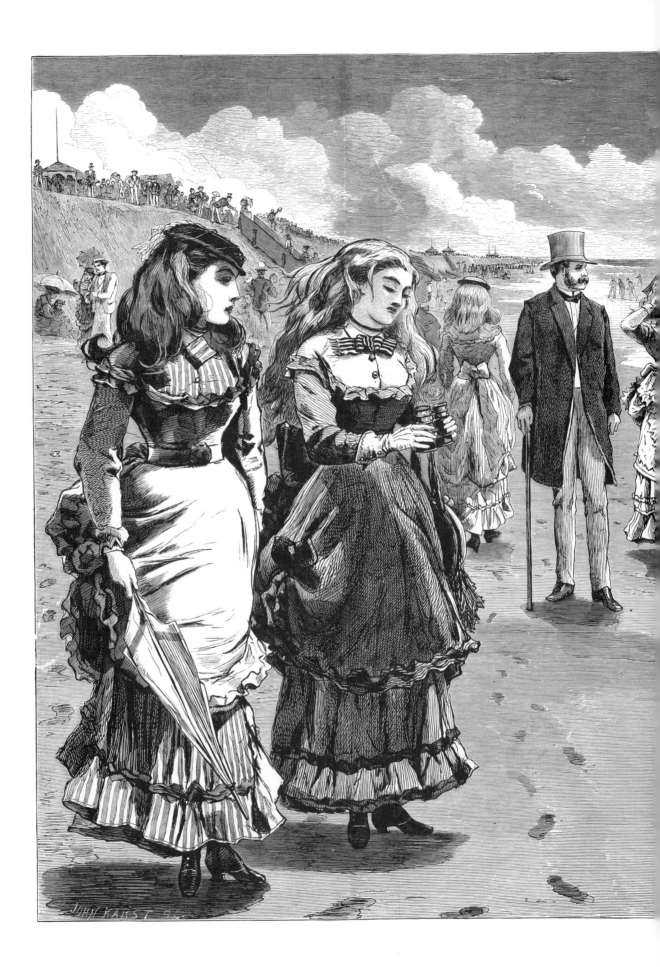

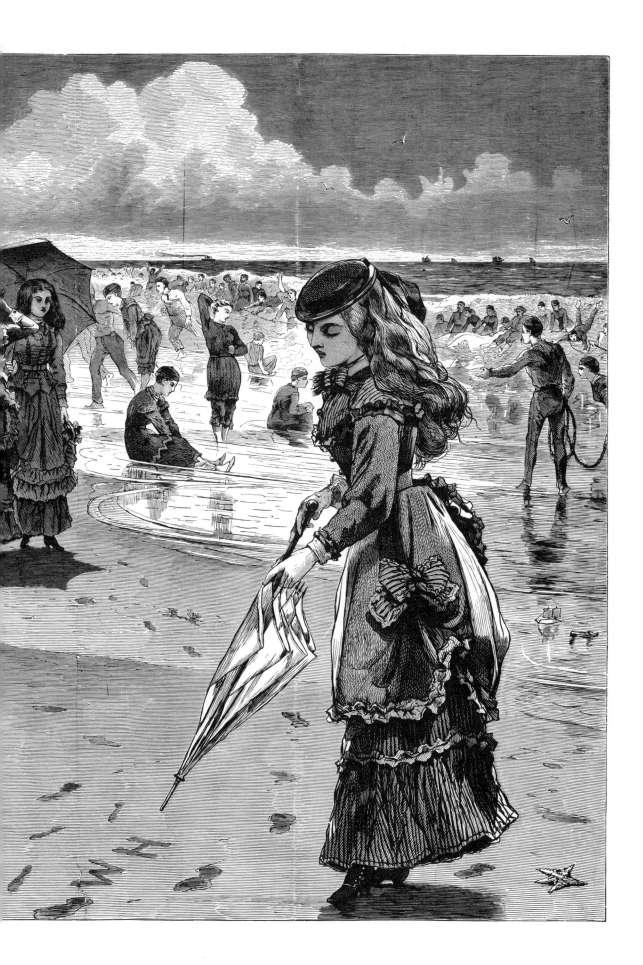

The Beach at Long Branch. *Appleton's Journal,* August 21, 1869. 13 x 19⅜ inches.

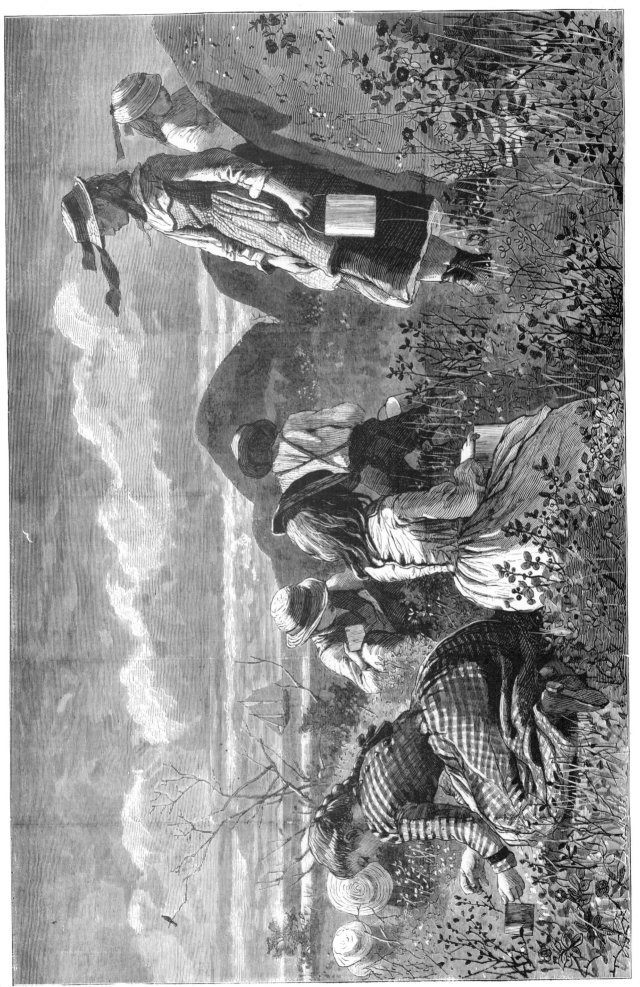

Gathering Berries. *Harper's Weekly,* July 11, 1874. 9⅛ x 13½ inches.

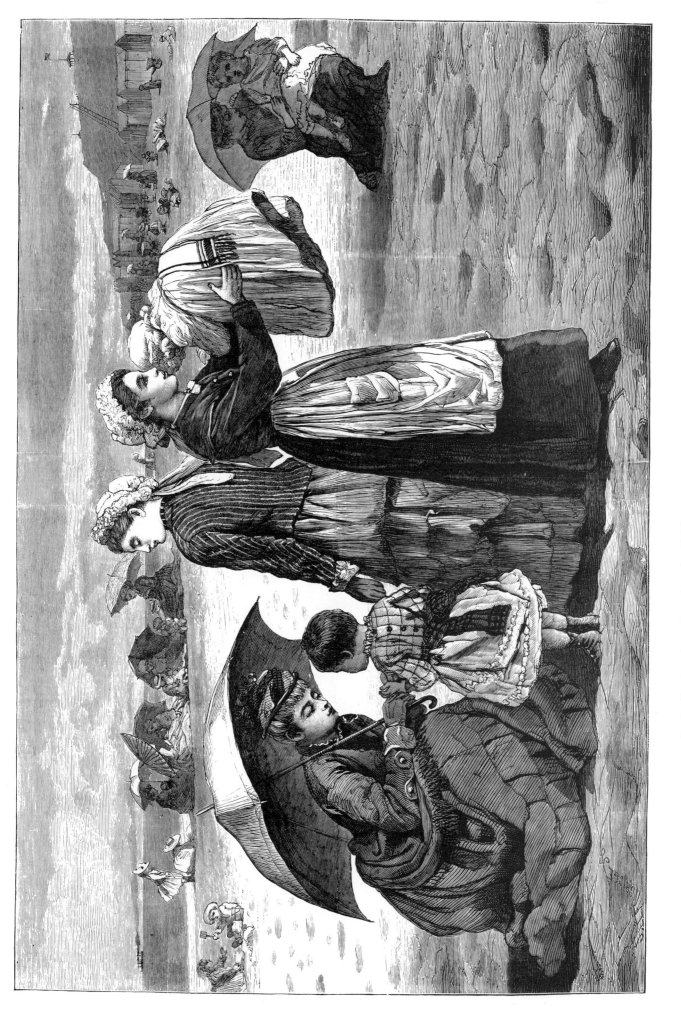

On the Beach at Long Branch – The Children's Hour. *Harper's Weekly*, August 15, 1874.
9¼ x 13⅝ inches.

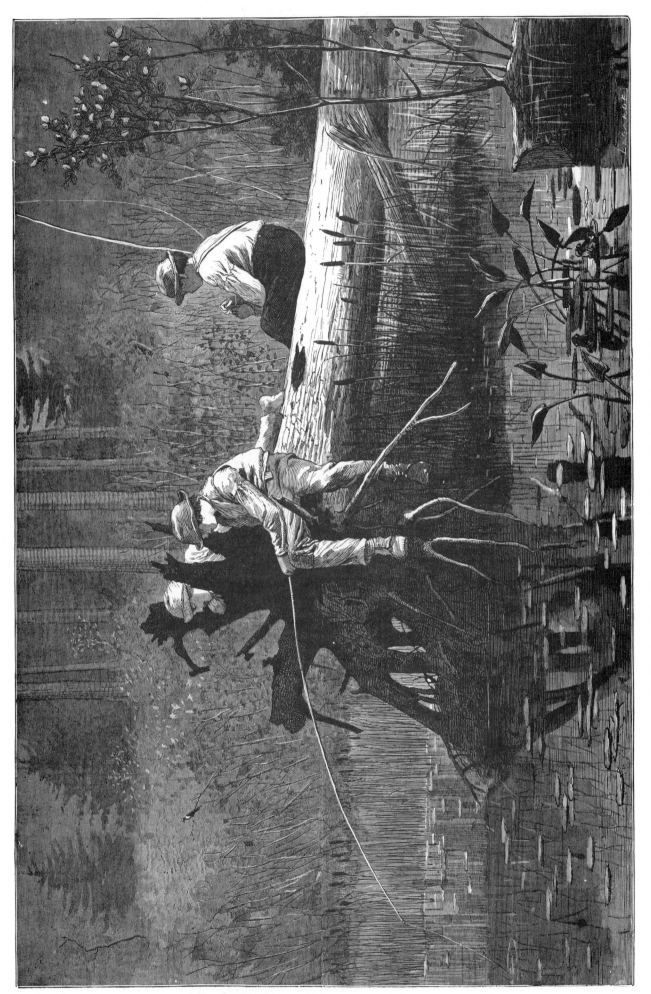

Waiting for a Bite. *Harper's Weekly*, August 22, 1874. 9⅛ x 13¾ inches.

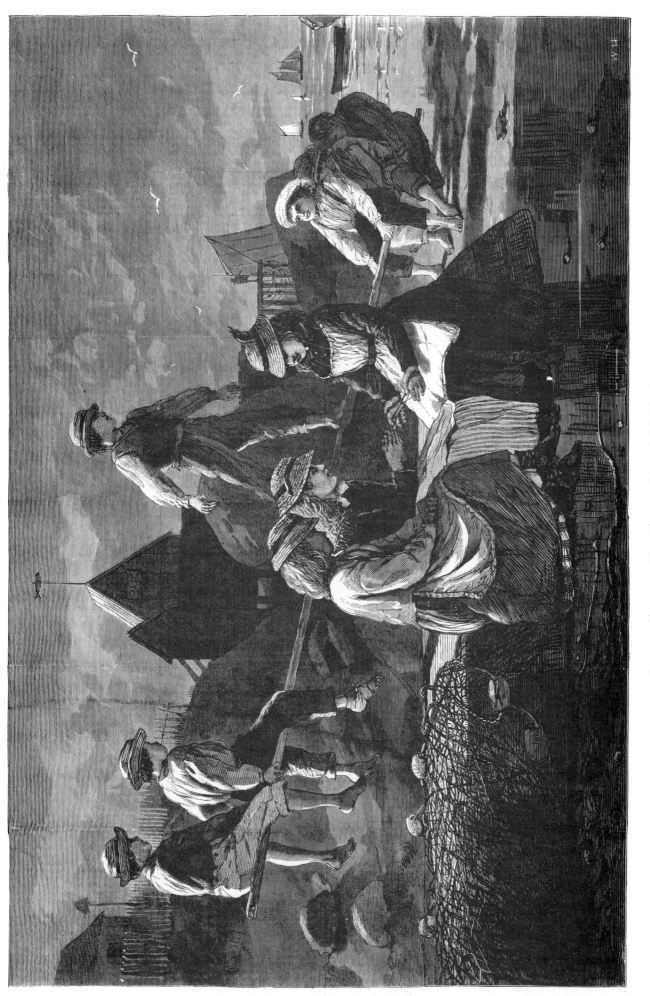

Seesaw — Gloucester, Massachusetts. *Harper's Weekly,* September 12, 1874.
9⅛ x 13¾ inches.

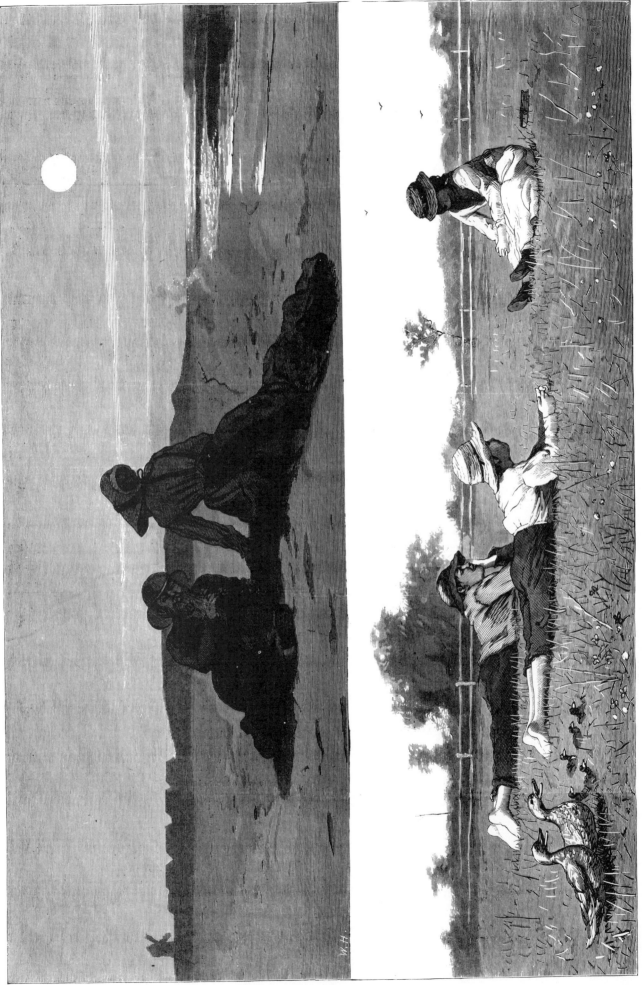

Flirting on the Seashore and on the Meadow. *Harper's Weekly*, September 19, 1874.
9⅛ x 13½ inches.

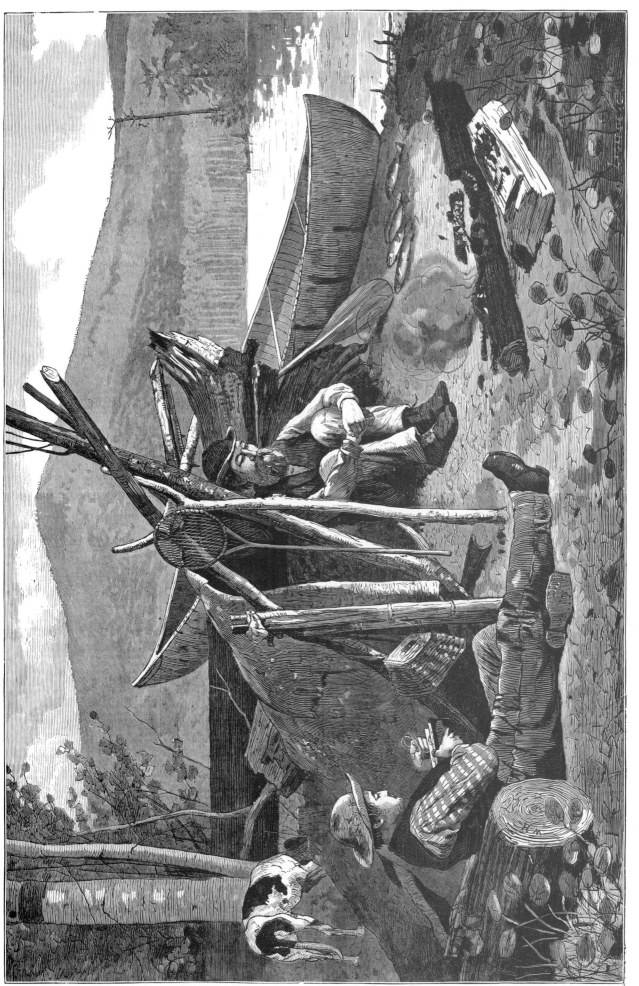

Camping Out in the Adirondack Mountains. *Harper's Weekly*, November 7, 1874. 9⅛ x 13¾ inches.